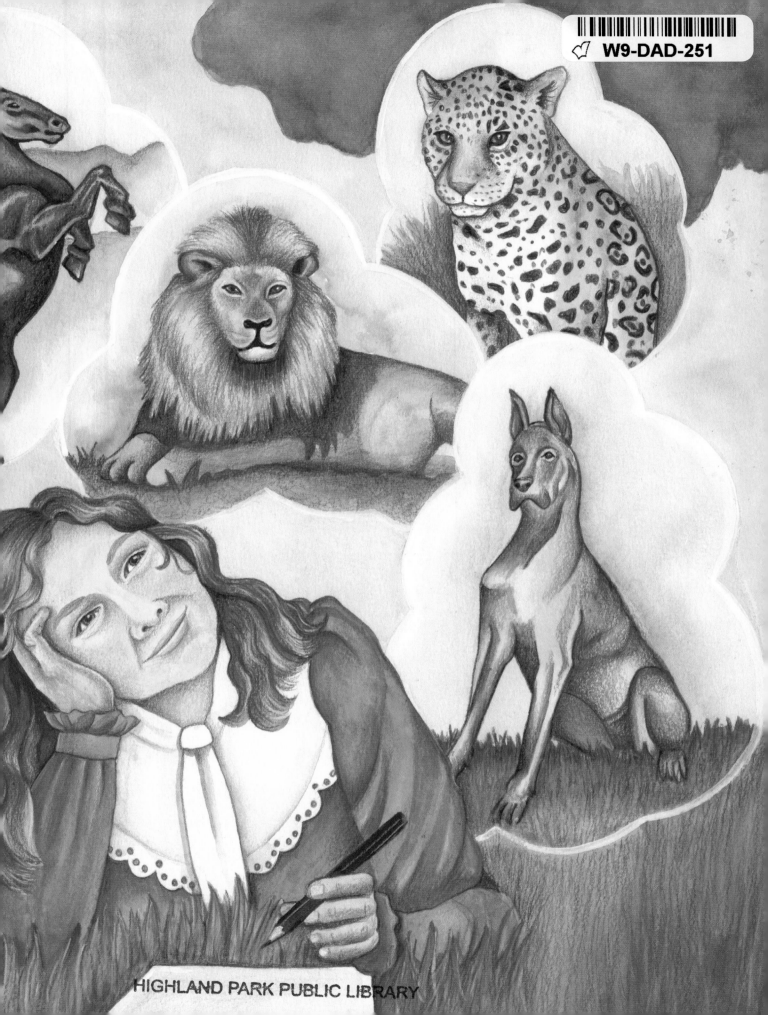

Dreaming with Animals

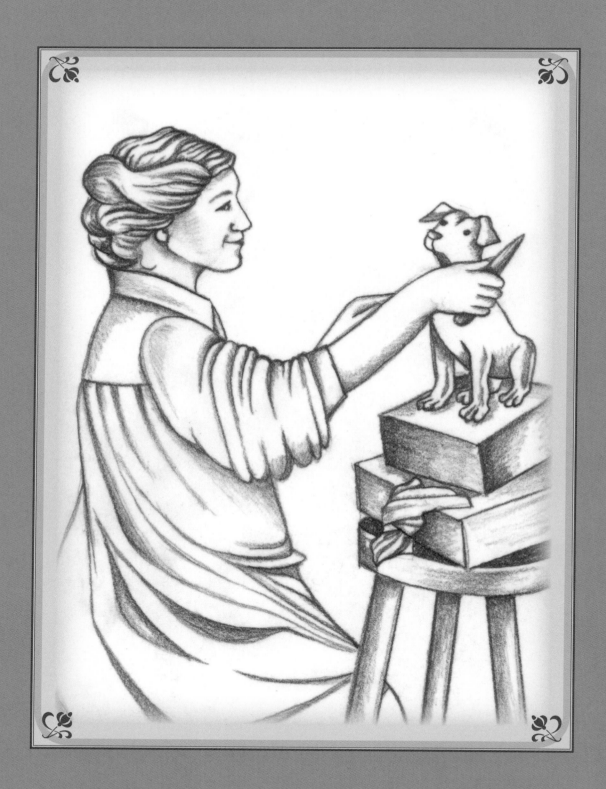

Young
Palmetto
Books

Kim Shealy Jeffcoat, Series Editor

Dreaming *with* Animals

Anna Hyatt Huntington *and* Brookgreen Gardens

L. Kerr Dunn *Illustrated by* Monica Wyrick

Foreword by Robin R. Salmon

The University of South Carolina Press

Published by the University of South Carolina Press
Columbia, South Carolina 29208

www.sc.edu/uscpress

Manufactured in the United States of America

25 24 23 22 21 20 19 18 17 10 9 8 7 6 5 4 3 2 1

Library of Congress Cataloging-in-Publication Data
can be found at http://catalog.loc.gov/.

ISBN: 978-1-61117-820-3 (hardcover)
ISBN: 978-1-61117-821-0 (ebook)

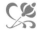

For my grandparents and parents, who taught me to love gardens

Contents

Foreword

The life of sculptor Anna Hyatt Huntington was long and successful, which sometimes makes writing about her a difficult task. L. Kerr Dunn has described engagingly Anna's upbringing and inspiration, even including the dreams she might have had as a girl and a young woman. Mostly self-taught in art, Anna found her training developed through her love of animals, both domestic and wild. Her ability to observe animals and to remember their activities allowed her to portray them accurately and with the spark that brings an artwork to life.

As one of the most successful sculptors of the twentieth century, Anna Hyatt Huntington has been a real role model, one who mentored many young women and men interested in becoming sculptors. This book will inspire and interest those who might be "dreaming" about art in general and animal sculpture in particular. It also presents two important life lessons—have the courage to pursue dreams and never give up. Anna Hyatt Huntington believed in her words: "I live in fear that I will become satisfied with what I do." She had the drive to become a great artist and, later, an important patron of the arts. That message comes across clearly.

Robin R. Salmon
Vice President of Art and Historical Collections/Curator of Sculpture
Brookgreen Gardens

Dreaming with Animals

One summer night in the 1880s, young Anna Hyatt was late for dinner. Her parents searched all over their Massachusetts farm, calling her name across the fields.

"Anna! Anna, where *are* you?"

"There she is!" Her mother cried, pointing toward the pasture.

Anna was lying on her stomach in the grass, watching a horse calmly chewing his dinner. Anna squinted at the smooth muscles in his upper legs and the strong curve of his spine. She wiggled closer and closer until her nose was only inches from his. She watched his teeth munch and his long eyelashes flutter. How interesting he was! Anna was so enchanted that she didn't even notice her parents approaching until her mother called out.

"Anna! We've been searching for you. You've missed dinner!" her mother said.

Anna hopped to her feet. Her dark red hair sprang wildly from her head, and her dress was smudged with dirt.

Excited to show off what she'd learned, Anna shouted, "Look, I'm a horse!" She began to trot in a circle, shaking out her imaginary mane.

Her parents couldn't help but laugh.

"How can we blame her?" her father asked as Anna galloped back toward the house. "It runs in the family."

It was true the Hyatts loved animals. In fact Anna's father was a well-known paleontologist—a scientist who studied animals. Anna tagged along with her father on field trips, where she learned to see the world with the eyes of a scientist.

"Look closely at every animal," he told Anna. "Notice every detail."

Anna's mother, a landscape painter who also helped illustrate Anna's father's books, gave similar advice about painting.

"Before you can paint anything, you have to *see* that thing clearly. Try to understand as much about it as you can."

Anna kept her parents' advice in the back of her mind, but at the time she wasn't interested in farm work like her older brother, Alpheus, or active in the visual arts like her older sister, Harriet. As a teenager she mostly thought about music. She dreamed of becoming a world-class concert violinist and even went to a private school in Cambridge to study violin. She liked the feel of the strings under her fingers and

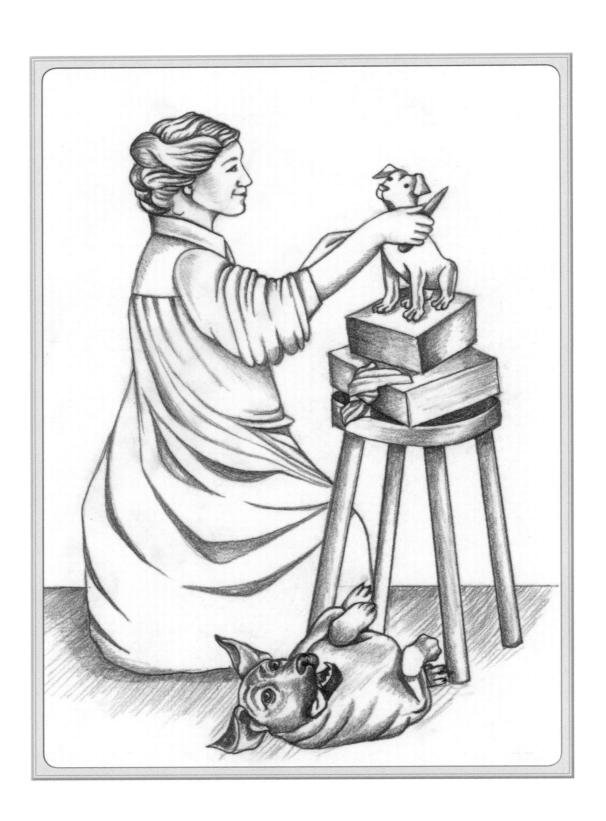

the hum of the violin's wooden body between her chin and shoulder. One piece of music sounded like a tree full of birds. Another sounded like a cat on the hunt. She lost herself in practice for hours.

Then one day Harriet invited Anna to help her complete an art project. Anna eyed Harriet's worktable. It was smeared with clay and cluttered with tools.

"What do you want me to do?" she asked.

"Well, I'm sculpting a boy. You could make a dog to go with him. You know animals so well," Harriet answered.

Anna picked up a piece of clay and rolled it across the palm of her hand. Somewhere inside of her a new, soft music began to play.

"I'll do it," she said.

As Anna studied their pet dog and began to sculpt, she quickly learned the challenge of having an animal model—animals didn't pose! Anna pushed her sleeves up to her elbows and planted her feet. Just watch, she told herself, thinking of her parents' advice. *Try to really see the dog. Try to feel what the dog feels.*

The dog barked and panted and rolled around the room. Anna watched and worked, studied and sculpted. She took care to get the details just right: the ears, the paws, the wagging tail.

After hours of work, she stopped and studied the sculpture from every angle. *I did it,* she thought. *I've captured the dog's true spirit.*

How exciting it was to make something so realistic. Her eyes darted around the room. What else could she sculpt? When could she get started?

When Harriet saw the final product, she threw her arms around Anna. "You should take lessons like I do, Anna. You're very good."

Anna felt prouder than when she was praised for her music. Was it possible that sculpture was her calling?

It was agreed that Anna should have lessons. In 1898 her father paid for her to study under the portrait sculptor Henry Hudson Kitson. Anna knew she was lucky, so lucky, to have the opportunity, but she had trouble sitting still during her lessons. Her feet tapped, and her mind wandered when she was supposed to be sitting quietly and learning. She wanted to roam the fields with the horses, to chase the dog. Her heart told her she could learn more watching animals than she could ever learn in a formal lesson.

"She's a free spirit," her father said.

"Yes," her mother agreed. "She needs to explore on her own."

Anna stopped taking lessons, but she was only beginning to chase her dreams. She lay in bed at night imagining how wonderful life would be if she could spend every day creating sculptures of her favorite animals. Mr. Kitson made a living as a sculptor, didn't he? Could a *girl* do that?

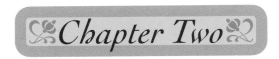

Anna in the City

A girl *could* do that, but it wouldn't be easy. To become the kind of artist she wanted to be, Anna would have to break the rules. In the early 1900s, young women of Anna's social class were expected to marry and take care of their homes and families, not build careers. Soon enough even Harriet married and, for a time, gave up art to focus on family life.

Anna was tall and pretty and could easily have married too, but she wanted something different. *I will never marry if I have to give up sculpture,* she thought.

Then, in 1902, Anna had a terrible loss. Her father died.

Anna felt like all the music in the world had stopped playing. Her father, more than anyone, had shared her love of animals and nature. He'd understood her need to sit and stare and imagine. He'd given her the freedom to work on her art. What would she do without him?

As she cried for him, Anna realized how short life could be.

"You're almost 26 years old," she told herself. "It's time to make a real try at being an artist. You're going to get up and make your father proud."

With newly found courage, Anna moved to New York City, where she shared an apartment with three other creative young women—two musicians and a sculptor. The girls had a wonderful time together, but they were serious about pursuing their dreams, and at night they collapsed after long days of hard work.

Anna had to be strong because the life of a New York artist was not easy. She learned this from watching her roommate Abastenia St. Leger Eberle, or "Stennie," struggle to sell her work. Stennie believed it was the artist's job to bring attention to social issues such as poverty, so she made sculptures of immigrants who lived in poor areas of New York. She was very talented, but many people felt her work was shocking because of its sad subjects. They would not buy her pieces.

Luckily for Anna, animal pieces were popular. Still, she had to compete to sell her work, usually with popular male *animaliers*—sculptors who specialized in animals. She also found it hard to enjoy art classes, just like when she was young. Like Stennie, she took classes at the Art Students' League under famous sculptors such as Gutzon Borglum, who created the Mount Rushmore monument, but Anna soon felt that

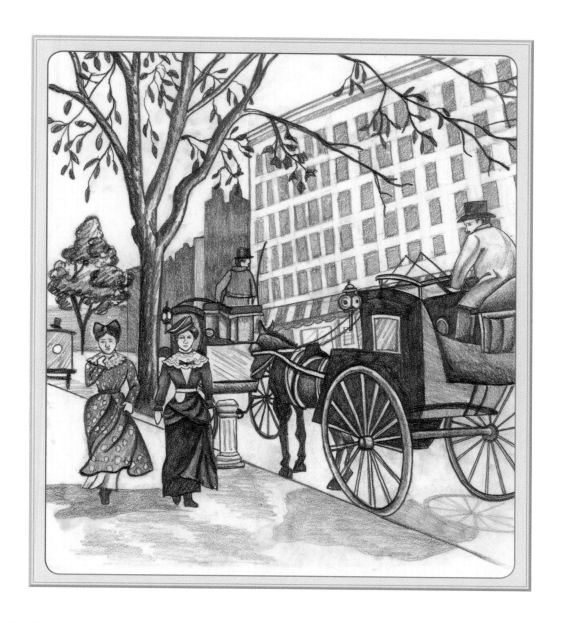

familiar itch to learn from animals themselves. Within a month of starting classes, she left school.

Seeking inspiration, Anna took frequent trips to the farm in Maryland that her brother Alpheus owned. On the farm she felt free as she rode and trained horses. Her skin sang in the fresh air, and her red hair grew warm in the sun. She thought of the green pastures of her childhood and renewed her promise to make her father proud.

Other days Anna spent hours at the Bronx Zoo, making small sketches—or models—in clay. In her studio she used the models to create life-sized pieces. Sometimes she relied on only the pictures she took with her mind; she had something called a "photographic memory" that helped her remember exactly how the muscles, eyes, or coat of an animal looked, even when the animal was in motion.

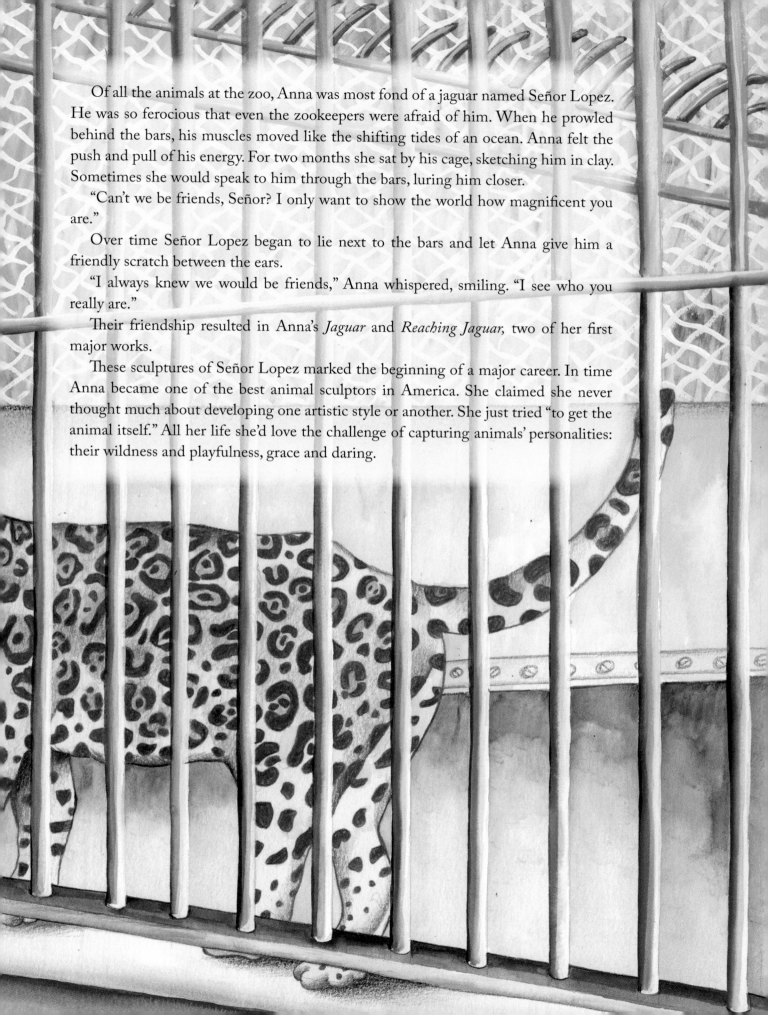

Of all the animals at the zoo, Anna was most fond of a jaguar named Señor Lopez. He was so ferocious that even the zookeepers were afraid of him. When he prowled behind the bars, his muscles moved like the shifting tides of an ocean. Anna felt the push and pull of his energy. For two months she sat by his cage, sketching him in clay. Sometimes she would speak to him through the bars, luring him closer.

"Can't we be friends, Señor? I only want to show the world how magnificent you are."

Over time Señor Lopez began to lie next to the bars and let Anna give him a friendly scratch between the ears.

"I always knew we would be friends," Anna whispered, smiling. "I see who you really are."

Their friendship resulted in Anna's *Jaguar* and *Reaching Jaguar,* two of her first major works.

These sculptures of Señor Lopez marked the beginning of a major career. In time Anna became one of the best animal sculptors in America. She claimed she never thought much about developing one artistic style or another. She just tried "to get the animal itself." All her life she'd love the challenge of capturing animals' personalities: their wildness and playfulness, grace and daring.

A Woman in Armor

Not everyone believed in Anna's talent. When some people saw her work, they didn't think it could be the work of a woman. One time in France, judges of the French Salon, a type of art contest, refused to give Anna an award because she was a woman. This was especially sad because Anna's sculpture was of Joan of Arc, who'd proved many years ago that women were as strong and able as men.

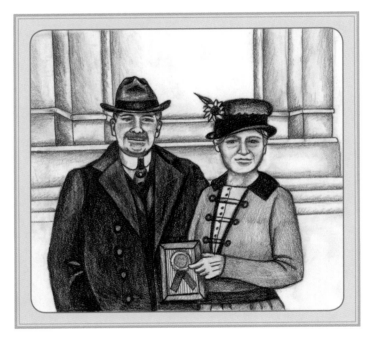

As a teenager Joan of Arc led the French in battle against the English in the Hundred Years' War. Up to that point, the French were losing badly. Then Joan took charge, led the French to victory in many battles, and eventually helped them win the war. Anna was inspired by Joan's courage. When Anna closed her eyes, she could see Joan plunging into battle, the sun glinting off her armor in a halo of light.

I want to make a Joan like no one has ever seen, Anna thought, knowing many other artists had sculpted the historical figure before. *My Joan will sit on her horse just before the battle. I'll re-create the 15th-century armor she actually wore. No other artist has done that.*

Over four months Anna toiled endlessly to get her life-sized *Joan of Arc* ready for the French Salon. When she was finished, she found herself staring up at an awesome sight: young Joan sat high upon her spirited warhorse, rising up in her stirrups with her sword lifted toward the sun for God's blessing.

Anna felt her own spirit stretch boldly to the sky. She knew her *Joan of Arc* was special. Surely she had a chance of winning a medal.

Unfortunately Anna's hopes were crushed. The judges at the French Salon agreed that *Joan of Arc* was dazzling and unique, but they didn't believe Anna created the impressive sculpture—not without the help of a man.

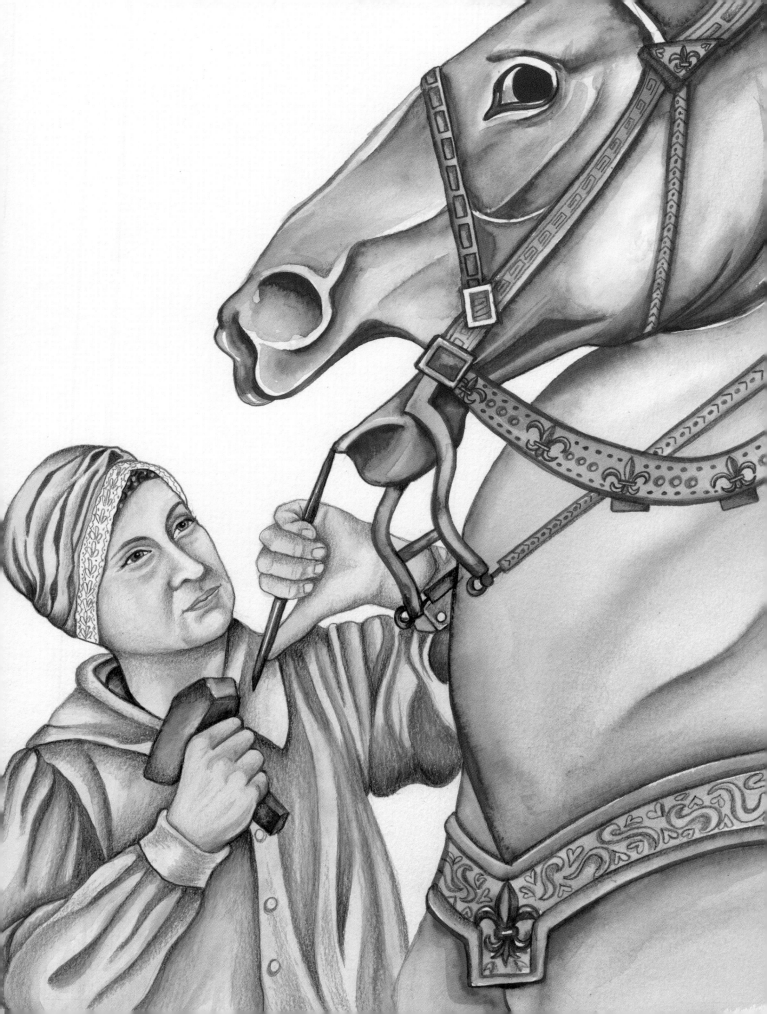

"We'll give you an honorable mention," they said. "But we can't give you a real medal."

Back in her studio, Anna brushed away angry tears. How could all those months of work end like this? Did they really think she was a cheater and a liar?

Anna wished that her mother and sister were with her. They were artists too. They would understand. In that moment she felt how far away home was, but she forced herself to shake off the sadness. She took a deep breath and straightened her back, imagining she was as fearless as Joan, a woman in armor. She'd lost this battle, but she would win the war.

Anna was right. Back in New York, she was invited to create a *Joan of Arc* for a park on Riverside Drive and 93rd Street, near the Hudson River. This time Anna made her sculpture even larger than life and cast it in bronze. She knew it would have to be wonderful because it was the first public monument that not only featured a woman, but was made by a woman.

On December 10, 1915, Anna's statue was presented to the public. The crowd cheered, and a band played as the French ambassador to the United States gave Anna an award. Finally both countries were honoring what a woman sculptor could do.

Anna's success with *Joan of Arc* made her reputation even stronger in America. That year Anna was one of only ten women in the United States who earned enough to support herself through art.

Chapter Four

The Art of Love

A thriving career. A studio in Greenwich Village. New projects in the works.

Anna was so busy that she hardly gave a thought to romance. Sculpture was the love of her life. Little did she know, it wouldn't be her only love for long.

One day the Hispanic Society of America contacted Anna about creating a special medal. When she went to meet the president and founder of the society, she found herself face to face with a well-dressed man sporting a furry moustache. *Is this the Archer Huntington I've heard so much about in social circles?* Anna wondered. He was a bear of a man. He stood straight and tall; his shoulders were broad. His eyes were clear and kind.

When he looked at Anna directly, those eyes sparkled with curiosity. Anna blushed when she realized she'd been staring too long. Why did he seem so different from other men? She had a feeling she'd met someone very special.

Archer Huntington was a multimillionaire from a well-known family, but he was not your typical millionaire. He was an art lover, scholar, and poet. He was also America's most important scholar of Hispanic culture. In 1904 he'd opened the Hispanic Society of America in New York. He'd been married once before, but now he was divorced.

As Anna and Archer became friends, Anna discovered they had quite a bit in common. Like Anna, Archer was well known in New York society, but he liked privacy and plenty of quiet time to work. Like Anna he wanted to dedicate his life to the arts. To top it all off, he'd been born on March 10—like Anna.

Anna wanted to believe this was a good sign, but she took her time getting to know Archer. She watched him carefully, the way she observed everything in life. She could tell he was not the type of man who would ask her to give up her own dreams. He was smart, creative, and generous. Anna's feelings of friendship deepened into something more. For the first time, Anna could imagine spending forever with someone. She was in love.

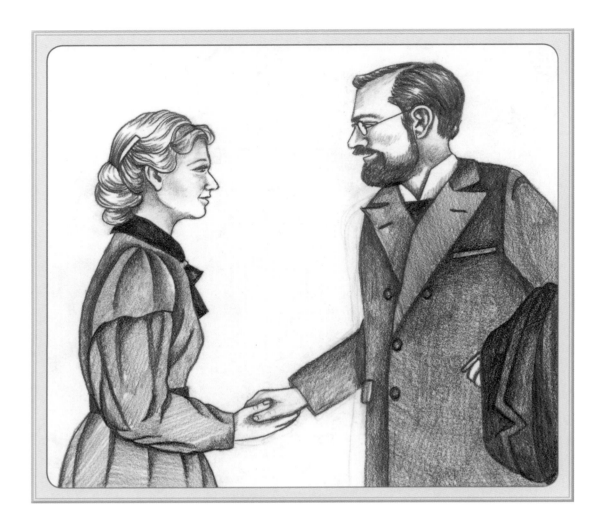

In 1923 Anna and Archer were married on their shared birthday in Anna's little studio. They kept the wedding simple, inviting only a small group of family and friends.

"From now on," Anna and Archer decided, "We'll call March 10 our three-in-one day. One day to celebrate two birthdays and one wedding."

At 47 and 53 years old, respectively, Anna and Archer had much to celebrate. Their love would last all the days of their lives.

In Sickness and Health

Once married, Anna could have worn fancy dresses and showed off the jewelry she inherited from Archer's mother. She could have spent hours posing for portraits like other wealthy women did. But for Anna work still came first. Even though it was the Roaring Twenties and many Americans partied and spent money recklessly, Anna and Archer were never wasteful. In fact they sold or gave away many of their material items so they could move into a modest townhouse on Fifth Avenue.

Work was not always easy, however. Anna got colds and fevers that she had trouble getting over. Sometimes she coughed up blood. She'd feared for a long time that she was very sick, and now she couldn't hide it from Archer.

"I know you're determined to work, Anna, but you must get well first," Archer insisted.

How could she stop working when a king was waiting on her? At the time Anna was making a statue of El Cid Campeador, a Spanish folk hero and warrior. Archer had translated an epic poem about El Cid into English, and he asked Anna to make an El Cid statue for the courtyard of the Hispanic Society. Another *El Cid* would be sent as a gift to the king of Spain.

If Anna didn't get better, though, she might never work again. She had tuberculosis, a life-threatening illness.

Anna and Archer decided they should go stay near a sanatorium—or hospital—in Asheville, North Carolina, a mountain town with plenty of fresh air. In December of 1927, they went there, taking their little dog Winkles. The mountains were beautiful, and Anna and Archer enjoyed a change of pace and scenery. They took strolls at night to watch the golden sunsets, and when it snowed, the trees were a heavenly white against the blue mountain ranges in the distance.

Even the beautiful setting couldn't lure Anna away from work forever. Winter turned to spring, and Anna's health improved. When doctors said she was healthy enough, she and Archer went home and made new plans for work and travel.

In the spring of 1929, they traveled to North Africa and Spain, where Anna was happy to see her statue, *El Cid*, in Seville. In Madrid, Anna and Archer were the

honored guests of King Alfonso XIII. As his guests they got invitations to dine with him and other royalty. Soon they felt worn out by all the visits and dinners, though.

"We have to go home and find peace and quiet," Archer told Anna.

"Yes," she agreed. "I know."

The stakes were higher than ever. Now her life depended on it.

Finding Brookgreen

Anna's sickness lurked in the background of her life, always threatening to return. The country was sick now too. The big money "boom" in America had come to an end in 1929, and the whole country entered a terrible time called the Great Depression. Suddenly many Americans had no money and no jobs.

In terms of money, Anna and Archer were lucky. Archer made wise financial decisions and saved their fortune. Their hearts ached for other Americans, but they still needed to find a winter home in a warm climate to help Anna stay well. In 1929 Archer got an ad in the mail that said that "Four Colonial Plantations on the Waccamaw River" were for sale in South Carolina.

Believing the ocean breezes and mild temperatures of South Carolina would be good for her health, Anna agreed to visit.

When she and Archer arrived in Georgetown County, South Carolina, they began to tour the plantations that together were known as "Brookgreen." They found the grounds in poor condition. Anna took note of the wild tangle of flowers and plants, an empty house, and the crumbling chimney of an old rice mill. The place needed plenty of work, but she and Archer could see its potential.

Archer knew he could fix up Brookgreen, build a home there, and help the local community in the process. Local African Americans, who were descended from freed slaves and spoke a language called Gullah, knew the land better than any one. Archer needed their help, and in exchange he offered them the opportunity to earn money and learn new trades such as carpentry and bricklaying.

Archer and these community members would build a coastal fortress with a high tower like the watchtowers Archer had seen on the south coast of Spain. He even wanted to name the home "Atalaya," the Spanish word for "watchtower." When they began construction on Atalaya in 1930, Archer saw that the workers needed better food, shelter, and medical care. He built a village of small cabins and a health clinic and gave each family food and supplies.

Doctors told Anna to rest, but she was determined to contribute as much as she could. She designed patterns for the ironwork of the doors, railings, and windows of Atalaya. Then she closed her eyes and fantasized about all the sculptures she'd create as soon as she was given the doctor's permission. A wild stallion, three young horses, a Great Dane, and other animals filled her mind. Even as her body rested, her imagination was always busy, her daydreams full of animals.

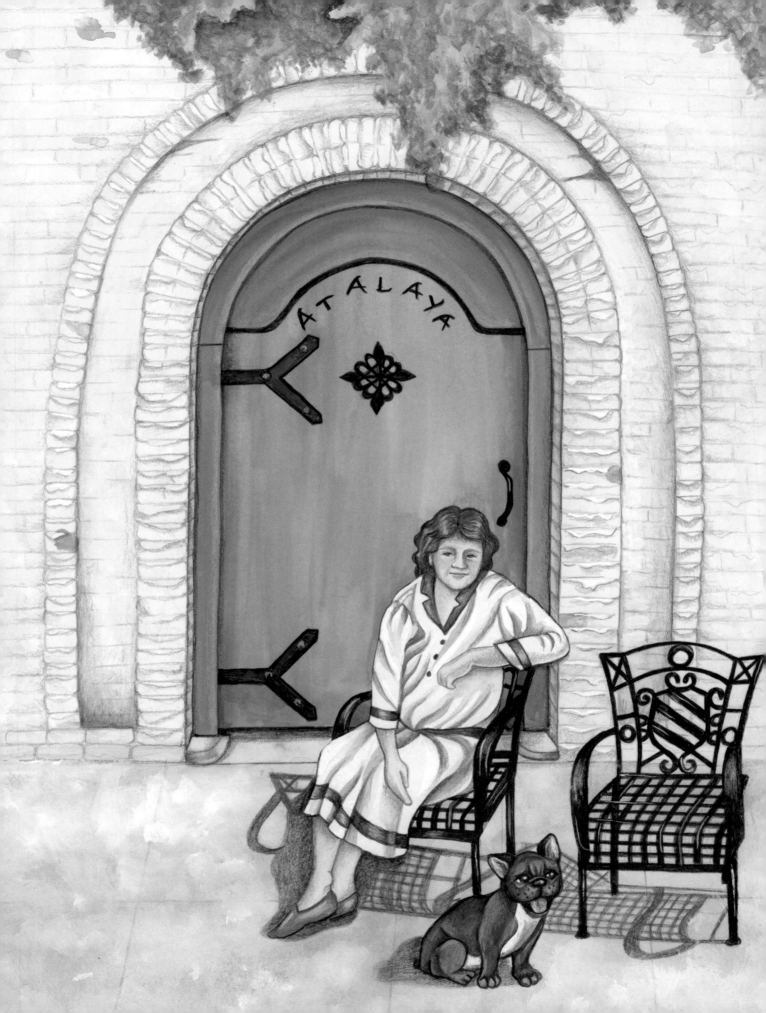

Building the Butterfly

The simple act of drawing made Anna feverish and dizzy. Still, in May 1932 she picked up pencil and paper and sketched out a design for a garden in the shape of a wide-winged butterfly. This butterfly was the heart of an outdoor space in which Anna's sculptures and the work of other sculptors would be displayed. The butterfly's three-pointed wings fanned out toward brick walls that enclosed the garden. Archer

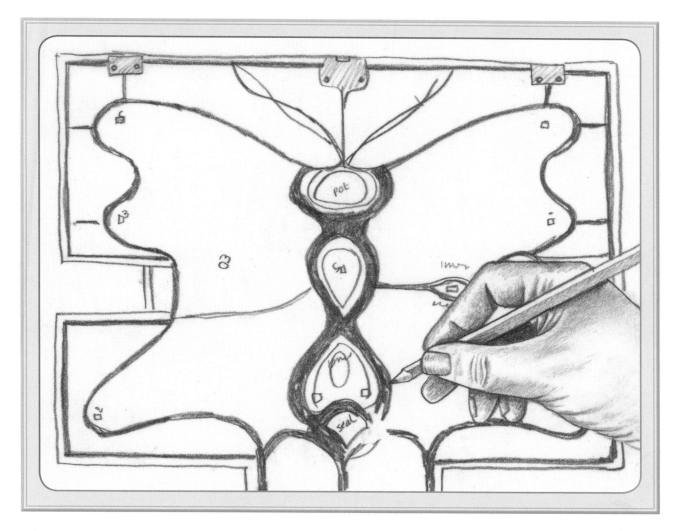

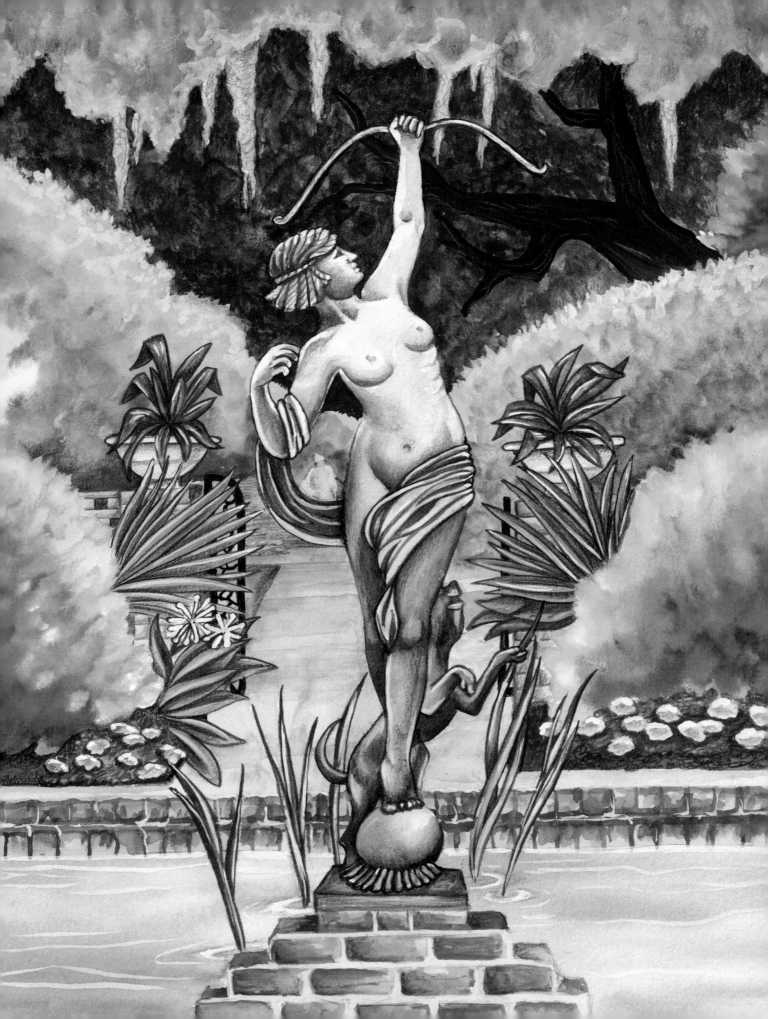

had poems carved into limestone slabs and set into the walls. He also created a plan for a wildlife sanctuary.

Brookgreen Gardens officially opened to the public in 1932. Archer called it "a quiet joining of hands between science and art." By the end of the decade, Anna had placed some of her favorite pieces there, including *Diana of the Chase, The Young Diana,* and a number of her animal sculptures such as *Lions, Brown Bears,* and *Wild Boars.*

Persevering through a decade of sickness, Anna collected almost 350 sculptures from artists all over the country. These works found homes among budding flowers, splashing fountains, reflecting pools, and wide, green lawns. Visitors came from near and far to admire the charm and beauty of America's first outdoor sculpture garden.

The Traveling Zoo

Brookgreen Gardens was only one of Anna's reasons to celebrate in 1932. In July, Anna was awarded an honorary degree in fine arts from Syracuse University, and in October she was the first female visual artist inducted into the American Academy of Arts and Letters. The art world knew how special she was.

Sadly the 1930s were also difficult years. Anna's mother died the same year Brookgreen opened. And, twice during the decade, Anna was so sick she had to return to sanatoriums, one in Switzerland and one in Arizona.

Anna's battle with tuberculosis kept her from sculpting for six years, and she fretted that she'd lose her creative ability forever. She was never quite herself when she couldn't sculpt. What if she'd lost her talent?

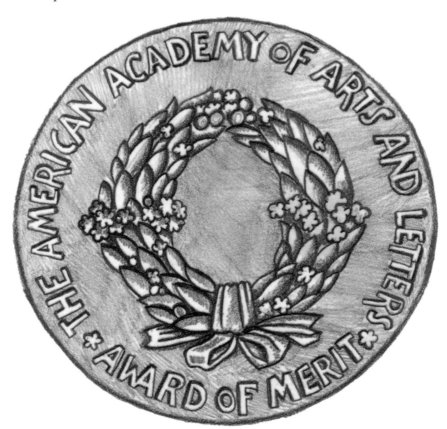

One day in January 1935, Anna was feeling well. As her greyhound dog, Echo, lay resting on the floor, Anna took a snapshot of Echo with her mind. Then she did one of her quick sketches in clay, set it down, and gave it a careful look. Her heart felt lighter.

I can still do this, she thought.

Back in New York, in a new summer home called "Rocas" (which means rocks) Anna completed several other studies of Echo. She captured Echo doing all sorts of doggy activities from lying down to licking, scratching, and playing with an old shoe.

The thrill of sculpting again was powerful. Anna was ready for more.

Anna kept monkeys, wild boar, and bears with cubs in a small zoo at Rocas. Using her animals as models, she quickly completed 40 sculptures. As if that wasn't enough, she started a dog kennel at Rocas too. She'd fallen in love with the Scottish deer-hounds and their long, gray coats, lean bodies, and gentle personalities. In fact she introduced the Scottish deerhound to the United States and eventually became an award-winning breeder.

Anna so loved her dogs and the other animals that when it was time to travel to Carolina for the winter, she just couldn't leave them all. Archer had a special trailer made big enough for them and the pets. On one trip that trailer was absolutely packed. Anna and Archer crowded in with four dogs, three monkeys, and a macaw. The dogs ran up and down the aisles while the monkeys swung about. What a sight the traveling Huntingtons must have been! Few people who saw that rolling zoo would have guessed that inside sat one of America's richest men and one of America's finest sculptors.

At Atalaya the macaw had a perch in the corner of the sunroom, and peafowls roamed the yard. Archer wrote poetry and conducted business in his study while Anna worked in her indoor-outdoor studio. When the sky was clear, she worked outdoors in natural light. When it was cold or rainy, she moved inside, where she had a huge skylight. She kept bears and monkeys temporarily in pens next to the studio for live models. In later years her horses Polly and Bob stayed in the stables nearby. Sometimes as Anna rested in the afternoon, a monkey sat on her shoulder and nibbled her ear.

The winter of 1937 at Brookgreen was a particularly active year for Anna. She worked with the horticulturist to find the perfect spots for several new statues that had arrived, rode her horses around the property near Atalaya, and took nature photographs. Archer worked on improving the watering systems for the gardens.

The childless couple found plenty of love and affection from their ever-growing animal family. Anna and Archer were, however, growing older. Sometimes, as they sipped coffee on the porch of Atalaya, Anna wondered how many more winters they had together.

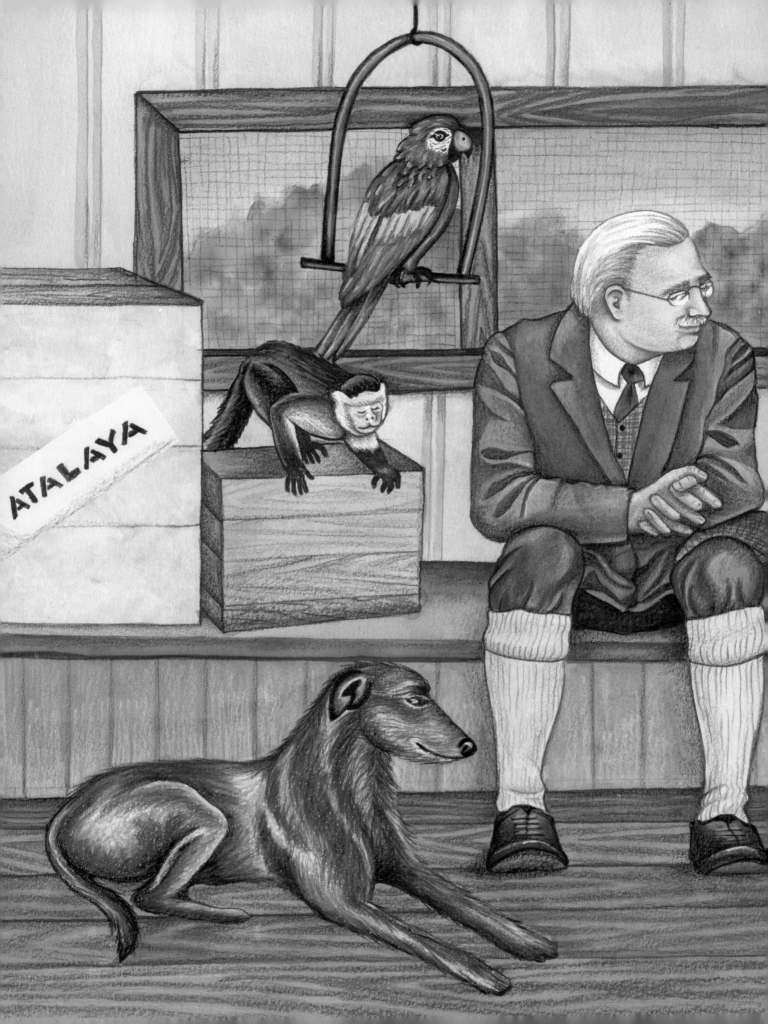

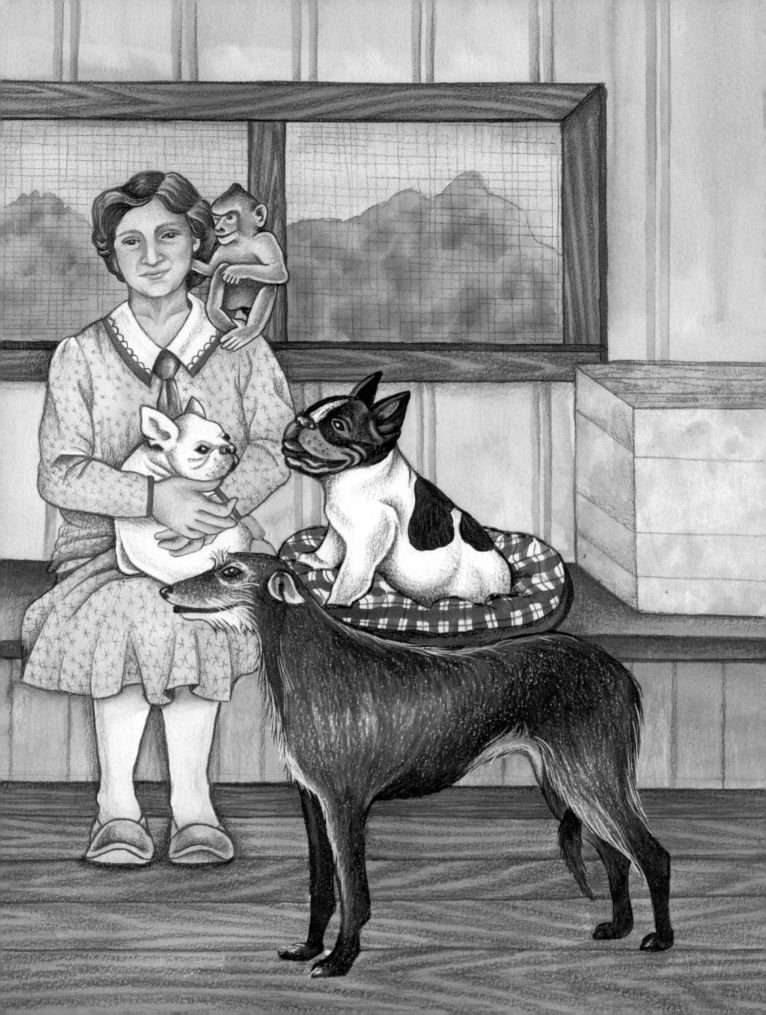

Catching Light

At 70 years old, when others her age had gone into retirement, Anna was still going strong. In 1946, after taking a long break from sculpting, she went back to work with grand plans.

First she made an enormous sculpture of the fictional character Don Quixote, a crazy old man who was famous for fighting windmills. Years before that one, she'd made a sculpture of Don Quixote heading into battle; now she sculpted him coming home on his old broken-down horse, Rocinante.

In 1950 she started another ambitious piece, a towering 17-foot sculpture of two horses engaged in a fierce battle, each with a rider on his back. The finished sculpture, called *Fighting Stallions,* was placed at the main entrance to Brookgreen Gardens in 1951. Anna created the sculpture to attract the attention of people driving by on the highway. Cast in aluminum, which Anna loved because it caught so much light, *Fighting Stallions* offered a first glimpse of the magical place that lay within the garden gates.

A few years later, one of the brightest lights in Anna's world went out. Archer passed away at the age of 85, dying peacefully in his sleep. With Archer's death the world lost a great poet, scholar, patron of the arts, nature conservator, and wildlife preservationist. Anna's loss was even greater. She felt like her other half was gone.

During their marriage, Anna and Archer founded at least four museums and financially supported several others. However, because Archer often donated anonymously, we may never know just how generous the Huntingtons were. In South Carolina they were supporters of the Charleston Museum and the Gibbes Museum. The Huntingtons could have used their wealth for their personal benefit only, but they chose to make South Carolina and the rest of the world a better place.

After Archer's death Anna didn't go into her studio for two months. Finally she realized her work would help her cope with her sadness. She'd lost one love, but she would not let go of the other.

Anna continued to work for 17 years after Archer's death, making over 70 pieces out of the more than 500 that she produced during her career. A number of these pieces included horses and famous people in their youth. American presidents Andrew Jackson and Abraham Lincoln were featured, one in *The Young Jackson* and the other in

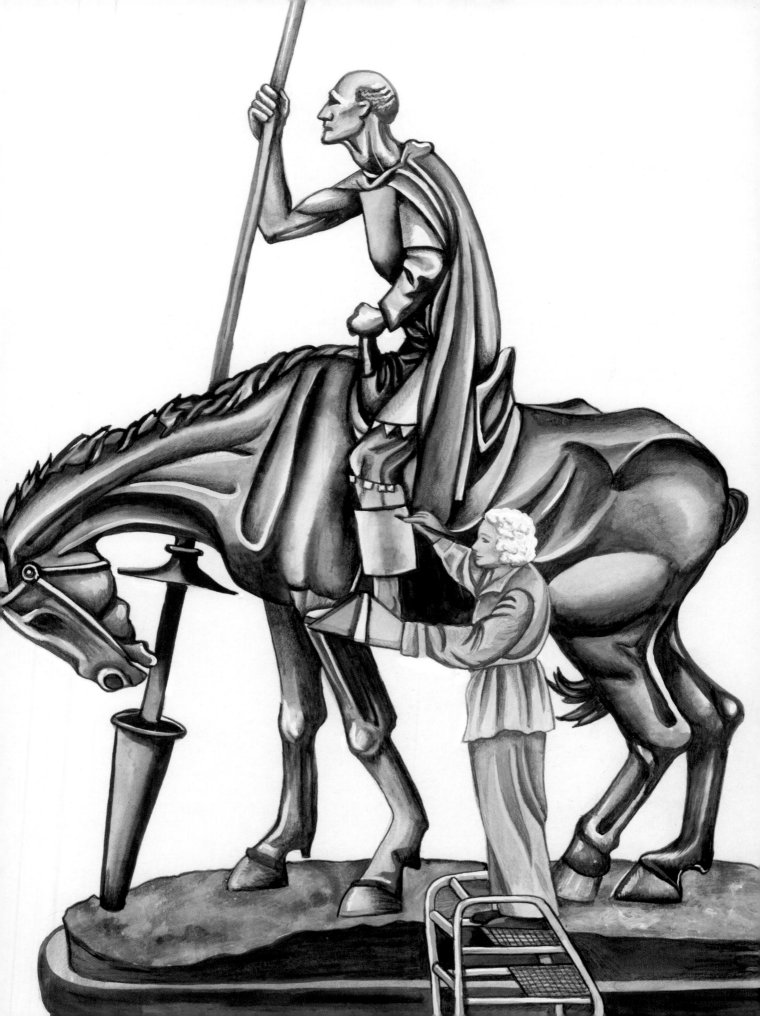

Young Abe Lincoln on a Horse. Even at the end of her career, Anna was still fascinated by her favorite animal. Two Revolutionary War figures and their horses were likewise her subjects, resulting in *Sybil Ludington* (or Lettington) and *General Israel Putnam*. In many ways Anna would always be that young girl lying in a pasture, studying the anatomy of a horse in the late afternoon light.

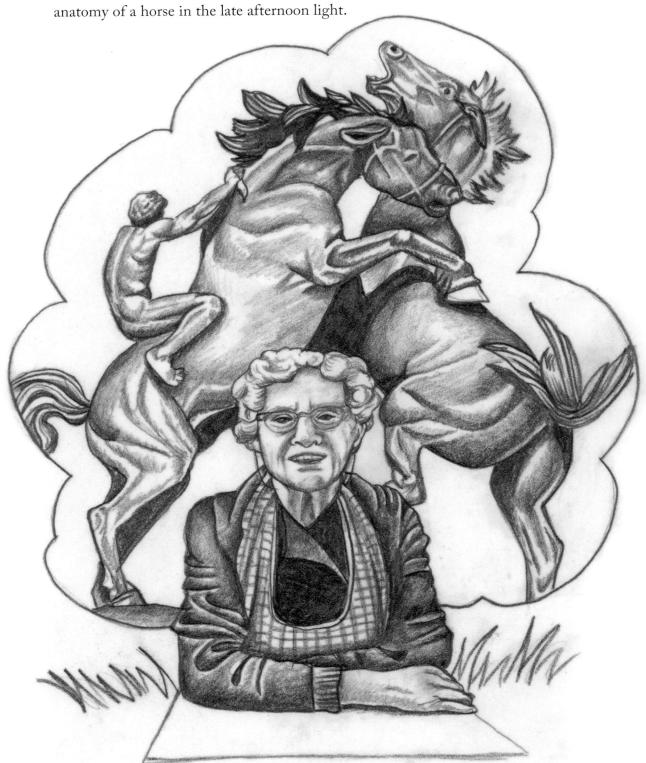

The Visionaries

When you visit Brookgreen Gardens today, you can stroll in the shade of the towering oaks that line Live Oak Allée or rest under the peaceful trellises around *The Fountain of the Muses*. In a small zoo, you'll meet river otters, gray foxes, and hooting owls. In the butterfly house, you'll marvel at the many wings flitting among clusters of exotic blooms. During the "Nights of a Thousand Candles," you can enjoy live music as a thousand small flames flicker across the water, atop the walls, and in the ancient trees.

And any time of year that you wander the grounds, you can read the poems etched into the walls of the garden. Look for a poem titled "Dedication" that Archer wrote for Anna before his death:

> WITH YOU IN SPLENDOR PAST ALL DREAMS' DESIRE
> I FOUND A WORLD LIGHTED BY LOVE'S TRUE FIRE.

Just a short stroll away you'll find *The Visionaries*, a sculpture of a young man and woman who sit side by side, heads bent together, as they study the plans for Brookgreen Gardens. Surrounded by animals, the couple represents the loving partnership that allowed Anna and Archer to picture and build such a special place.

Anna was a visionary, but she was never just an idle dreamer. She worked hard all her life, excelled as an artist, and never let go of her passion for sculpting. When she died in 1973 at the age of 97, it was the years, not tuberculosis, that took her. Even so, she'd worked on major projects into her 90s.

All her life Anna followed the music of her own heart, staying in touch with her truest self. As an artist she stayed true to her subjects too. She re-created what she saw on the outside, and captured the spirit shining through from inside.

Close your eyes right now and imagine Anna working on one of her animal sculptures. Her sleeves are rolled up. Her modeling tool is in hand. She watches intently as her animal moves about. She takes pictures with her mind. She's not waiting for the animal to pose. She knows if she waits long enough, watching, the animal will teach her what to do.

Acknowledgments

I owe a great debt to Robin R. Salmon, vice president for collections and curator of sculpture at Brookgreen Gardens. She is the preeminent expert on Anna Hyatt Huntington, and I have been lucky to have access to her expertise. Robin is a kind and generous person, and this book would not have been possible without her.

Thank you, Jonathan Haupt and Kim Shealy Jeffcoat, for believing in this book and including it in the Young Palmetto Books series. Thank you also to Bill Adams for his kindness and professionalism as managing editor and to Judith Kay Adams for her masterful copyediting. Linda Haines Fogle, Suzanne Axland, and the entire staff of University of South Carolina Press have been lovely and helpful. Many thanks also go to Monica Wyrich for enjoying an afternoon at Brookgreen with me and creating amazing illustrations that elevate this book.

My colleagues Jennie Ariail, Tom Smith, Shannon Richards-Slaughter, Christy Huggins, John DiNolfo, and Michael Madson are a constant source of support and encouragement.

The Kerrs and Dunns have made great memories at Pawleys Island, Litchfield, and Murrells Inlet over the years, including visits to Brookgreen Gardens. Thank you to Jimmy, Bunny, Jamie, Liane, Collin, Riley, and Jack Kerr along with my husband and son, Jack Dunn and Zak Kerr-Dunn, for more than ten summers of family fun. Love also to John and Katie Dunn, Marty Dunn, Nancy Little and all our family in Columbia. I hope Thomas and Kristen Little's girls will one day enjoy this book.

Finally, I say thank you to Anna Hyatt Huntington for living a life less ordinary, a life of hard work and perseverance. I can only hope I've done her some measure of justice with this story.

Bibliography

Evans, Cerinda W. *Anna Hyatt Huntington.* Newport News, Va.: Mariners Museum, 1965.

Foner, Daria Rose. "Anna Hyatt Huntington's Jaguars." *Wild Things: The Blog of the Wildlife Conservation Society Archives.* Wildlife Conservation Society. Retrieved July 7, 2014. http://www.wcsarchivesblog.org/anna-hyatt -huntingtons-jaguars/

Mitchell, Mary, and Albert Goodrich. *The Remarkable Huntingtons: Chronicle of a Marriage.* Pawley's Island: Litchfield Books, 2008.

Rubinstein, Charlotte Streifer. *American Women Artists.* New York: Avon, 1982.

Salmon, Robin R. *Brookgreen Gardens.* Images of America. Charleston, S.C.: Arcadia, 2006.

Salmon, Robin R. *Sculpture of Brookgreen Gardens.* Images of America. Charleston, S.C.: Arcadia, 2009.

Seckler, Dorothy. *Interview with Anna Hyatt Huntington.* Connecticutt, circa 1964. Retrieved September 13, 2016. http://www.aaa .si.edu/collections/interviews/oral-history -interview-anna-hyatthuntington-11738

South Carolina State Museum. "Anna Hyatt Huntington." Retrieved July 12, 2014. http:// scmuseum.org/women/Huntington.html.

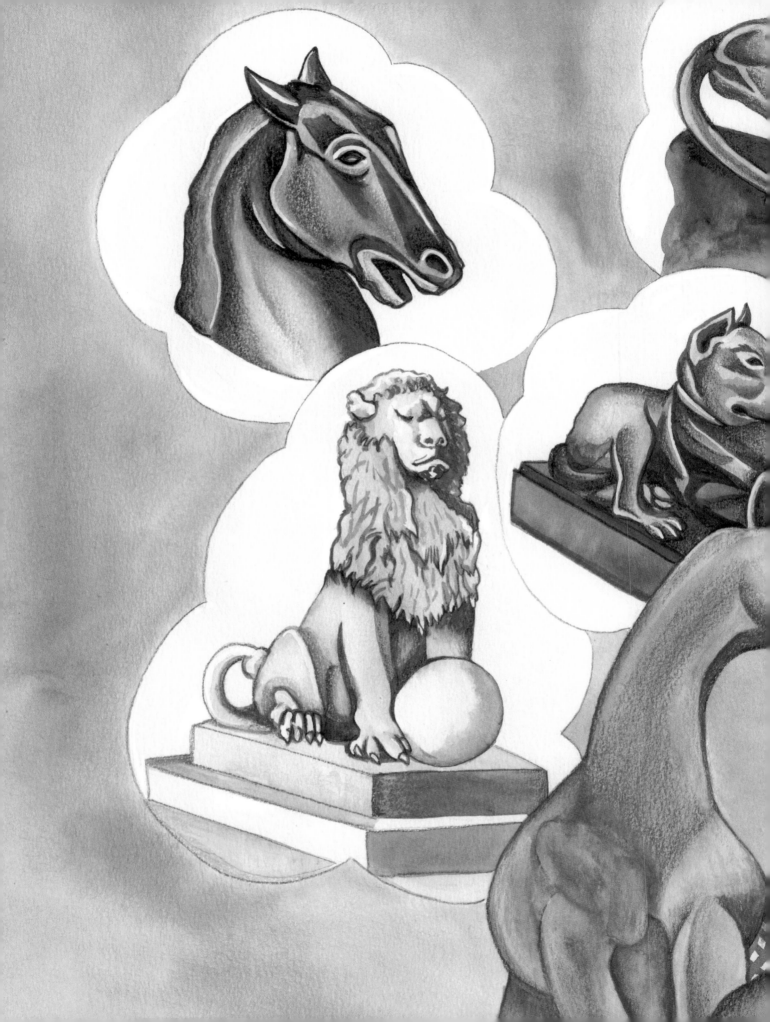